второй.

©ABNCo

ВЕННЫЙ

ШНЫЙ ЗАЕМЪ 1917 ГОДА,

го Правительства отъ 11-го Августа 1

[*Filthy Luker*]

rubber stamping, whereas others, like the sections on postcards or games, focus more on untouched artifacts.

To be honest, it makes little difference to me whether I end up adding to a piece or not. I get the same excitement from hunting down, selecting, and giving a home to these items as I do from physically manipulating them. When I put something I have chosen in a file drawer or in a frame, its meaningfulness to me comes from its elegance of composition, its humor, or its universality.

Everything in *Urgent 2nd Class* was cheap! The bits and pieces came from junk stores, garage sales, online auctions, storerooms, and sometimes garbage piles. There is no guilt or worry over the destruction of museum-quality material because nothing here cost more than ten dollars. This figure indicates not miserliness but merely a boundary that allows me to know that whatever I do I am not defacing something of real historical value. If damaged or dull ephemera can be given a new purpose, so be it.

The concept of order and chaos overlapping one another intrigues me. Whether it be vine-engulfed ruins or a new edifice emerging out of the jungle, there is something stimulating about the codependence of the contrived and the organic. Maybe that's why so many of us feel affection for weather-beaten,

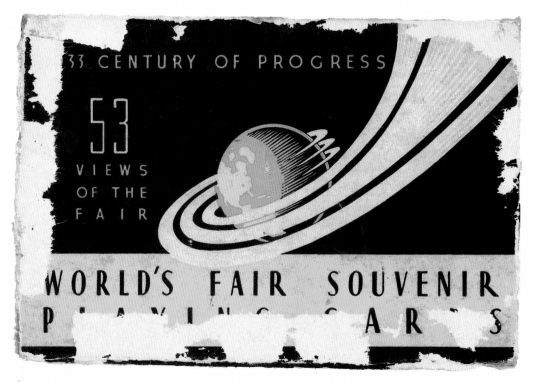

[*Chicago World's Fair Card Box*]

barnacle-encrusted ship's figureheads or ancient sculptures with lopped off arms. As Walt Whitman put it, "The weed will win in the end." It's a pleasing idea, not because it takes pleasure in the ultimate demise of civilization, but because it is an affirmation of change.

I'm inclined to think that we, the children of the latter portion of the twentieth century, bought the Emperor's New Clothes when it came to art philosophy. We've accepted a line of thought implying that aesthetics are purely a matter of individual taste and personal whim. Ironically, in so doing, we've laid ourselves open to be led by cheap fad. Though it may not be a popular view, I believe that there is a universal aesthetic, an internal visual balance mechanism that defines beauty and composition. This means that the opposite is also true—equality is admirable, but why kid ourselves that ugly doesn't exist. Awareness of balance and harmony is

< 4 >

something that needs to be worked on and developed within us.

As much as I respect the well-lit giants of the Renaissance, I'm not making an elitist plea for "high art." On the contrary, this book tries to show that good art can be found in many a dark corner. It just has to be discovered, played with, nurtured, and appreciated. Only when we develop a strong sense of aesthetic within the everyday will we avoid having crude and clumsy uglification served to us in the name of art and personal taste.

So what am I encouraging you to make? Not forgeries or fakes. There is no pretense to hide the concept of fantasy and no attempt to suggest something is other than what it appears. What I want to show is that a little wit and guile can move us backward and forward within an artifact's history, giving us an enhanced sensitivity toward the archaic and the ever malleable. In so doing, we allow ourselves to develop a creativity rooted in something stronger than the transience of fashion.

If I can help other artists find their own personal species of outsider art, maybe we'll further widen the eyes of all those who take delight in the visual world.

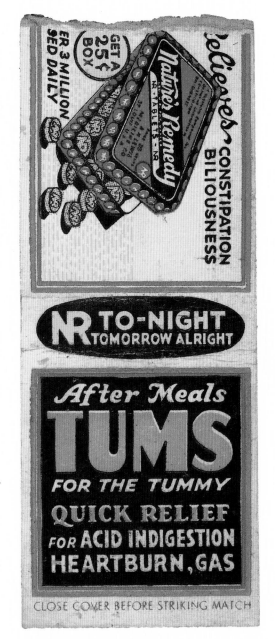

[*Heartburn Matches*]

< 5 >

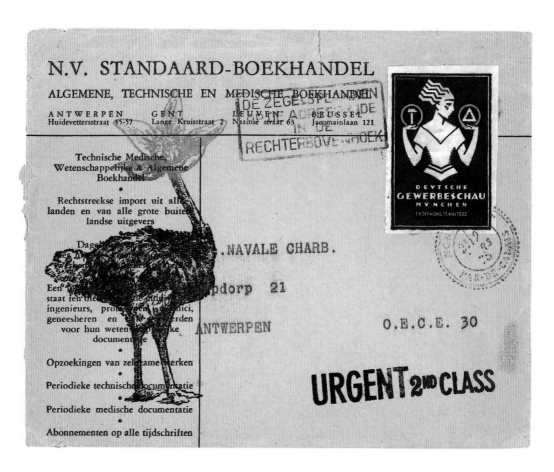

[*Ostrich Flower*] A rubber stamp and a Cinderella (see Stamp chapter) can be enough to change an envelope's whole personality.

< 6 >

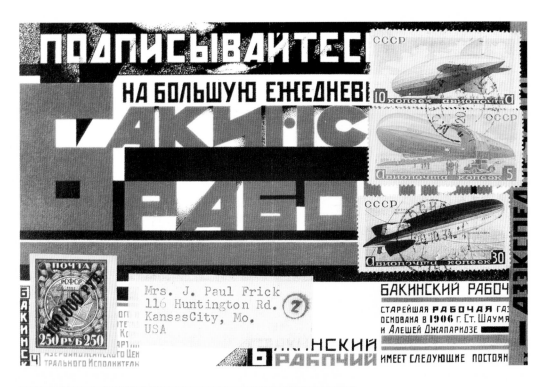

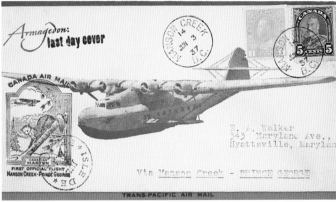

[*Airships and Seaplane*]

ABOVE: I joined together sections of a 1920s Russian poster, and then added the airship stamps, the cancels, and the address.

LEFT: The Canadian airmail came with the beaver, but I added the end-of-the-world notification.

< 11 >

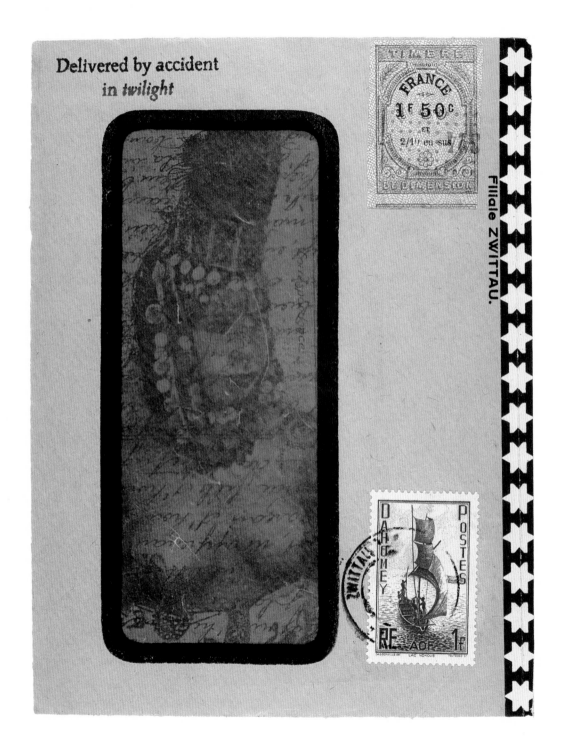

< 12 >

Money

Paper money was first conceived by the Chinese in the seventh century and was called "flying money" for its lightness and ease of transportation. Three centuries later they had a well-developed and relatively smooth system of countrywide exchange. After Marco Polo returned to Europe from China in the thirteenth century, he mentioned this paper money to his contemporaries, who were used to coinage. They laughingly dismissed his story as obvious fantasy. How could anyone use a currency that wasn't valued in terms of the metal it contained?

The Spanish began printing banknotes in 1483, but all of these early occidental issues were destroyed in the Siege of the Moors. When the rest of Europe finally committed itself to paper money, the printing method used was engraving—a technique that not only helped instigate a new era in fine design but also became a major weapon in the battle against forgery (a problem that the Chinese had struggled with from the outset). Governments and printers still go to great lengths to manufacture banknotes that are tough to copy. Up until recent years the combination of watermarked paper and complex machine-tooled engraving gave the authorities the edge on any illicit platemakers. With the advent of sophisticated computers, however, the struggle to keep counterfeit money out of circulation has gradually become more difficult.

When gathering paper money, you can purchase many magnificent items for next to nothing. The German period of high inflation in the 1920s, for example, gave rise to barrowloads of paper money that was virtually worthless, even though the design and coloring were of a high quality.

The facing page shows a collage of four German banknotes, some cut and some torn. It's worth observing the subtly emotional difference one experiences between the sliced and the ripped paper.

[*French Flag*]

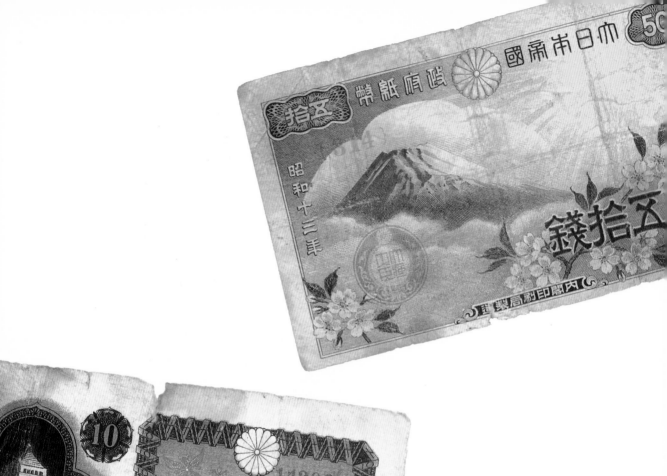

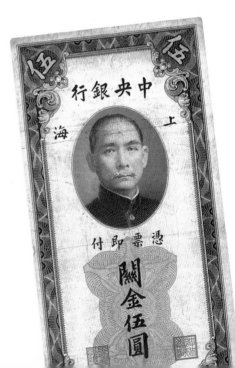

[*Orient*] From my box of bruised bills came
these scattered Chinese and Japanese notes.

< 36 >

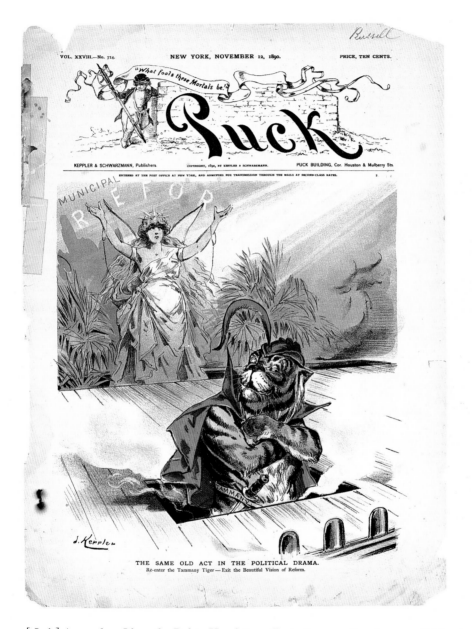

THE SAME OLD ACT IN THE POLITICAL DRAMA.
Re-enter the Tammany Tiger — Exit the Beautiful Vision of Reform.

[*Puck*] As much as I love the Robin Hood tiger illustration, my favorite part of this cover is the amber color of the withered tape in the top corner.

[*Kyoto Bottle*] In contrast to the illustrated man, the Kyoto Bottle is a nice example of lithographic printing.

FACING PAGE: [*Mr. Bradbury*] This illustration of a tattooed man from an early travelogue is not exactly the sharpest printing but that in itself gives it an interesting quality.

Kyoto bottle

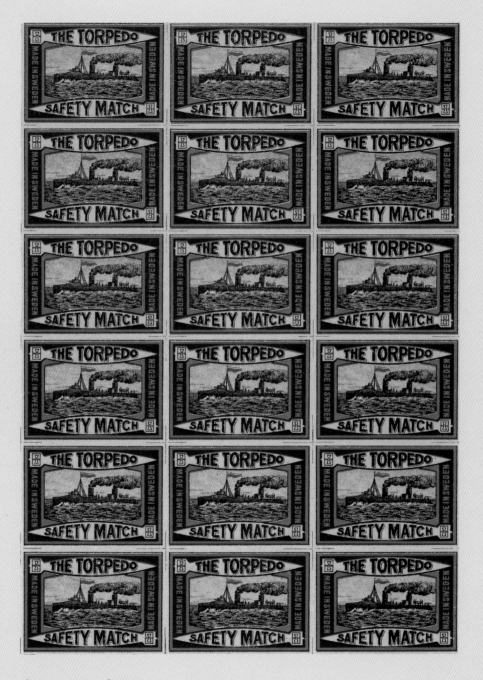

[*Uncut Matchboxes*] Nearly all small printing jobs were done as repeat images that were ganged together and then cut after the inks had dried.

< 62 >

Commercial Ephemera

How do you begin to explain to someone who doesn't get it, why you think a King Pelican iceberg lettuce crate label is truly stunning? As soon as I saw the label on page 64, I started leaping around with excitement. Its style is clearly of another era, yet it's not the slightest bit dated. There's no real marketing relationship between lettuce and a pelican wearing a crown as far as I can see, which adds to the perfection of the label. It works simply because whatever it's advertising has to be worth getting.

Once I started to look around, I was astounded at how many different products used to put their heart and soul into dramatic and colorful promotion. Matchboxes and matchbooks, cigarette cards, luggage labels, fruit labels, seed packets, travel posters and tickets—the list is endless. I even discovered thirteen great-looking 1920s broom-handle labels— I didn't even know that brooms had labels!

At auction I bought three sheets of uncut Swedish matchbox labels. It was a tough choice which sheet to include, but in the end the "Torpedo" battleship won over the llamas and the tigers. I couldn't resist seeing the eighteen ships chugging remorselessly across the page like still frames from an interminable Andy Warhol movie.

I don't want to get too euphoric here because there was an awful lot of dreary and downright bad commercial art. Nevertheless, it seems ironic that some of the best art of its day can be found within the normally predictable and repetitious world of advertising.

[The Demonic Wine]

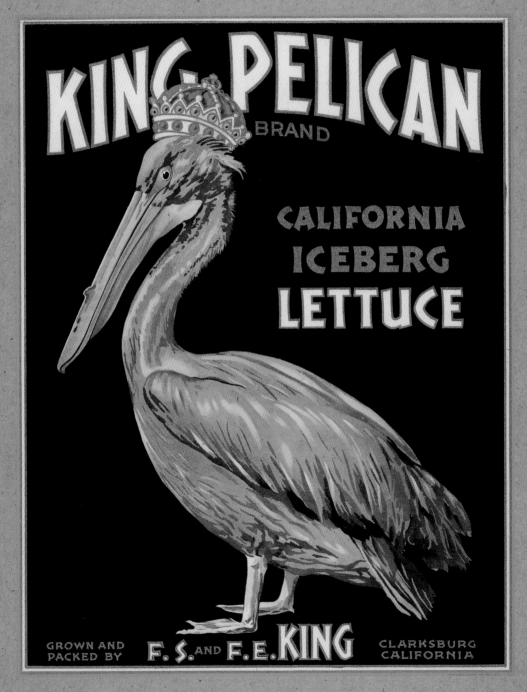

[*Iceberg*] I once heard Marvin Gaye say in an interview that after he recorded "Heard It Through the Grapevine," he had no realization that he had produced something special. I wonder if the King Pelican's illustrator exhibited the same after-the-fact matter-of-factness.

< 64 >

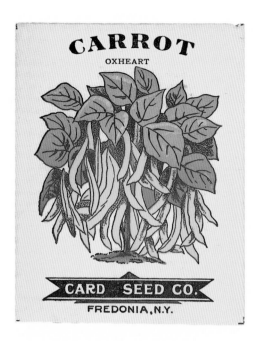

[*Seeding*] The drawings of these vegetables are so fresh it's hard to believe the seeds wouldn't still grow a plump specimen or two. With a little dexterity titles can be switched and cross-pollination can be achieved.

[*Travel and Tickets*] The travel industry has always put a lot of energy into advertising. Big, colorful old posters are now highly sought after and expensive, but you can still buy cheaply things like an early London Underground map or evocative old tickets to faraway places.

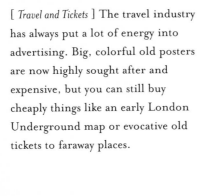

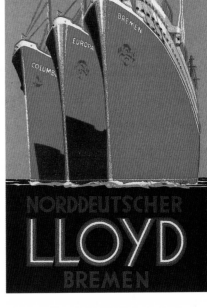

FACING PAGE: [*Smoking Tires*] Cigarette companies gave away a card in each packet. You could collect a whole set while you were asphyxiating yourself. This Road Safety series has a wonderful innocence about it.

< 66 >

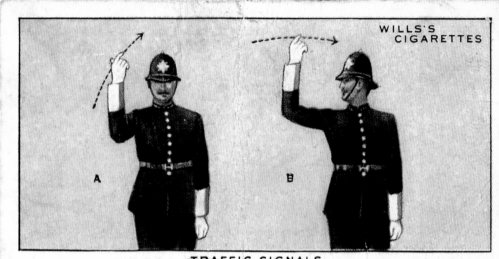

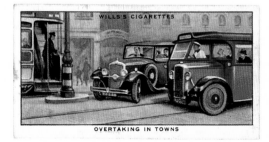

NEVER CHASE A BALL OR HOOP INTO THE ROADWAY

TAKE THE OFF SIDE OF THE ROAD WHEN MEETING LED HORSES

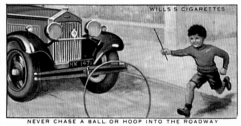

NEVER DRAW UP AT NIGHT ON THE WRONG SIDE OF THE ROAD

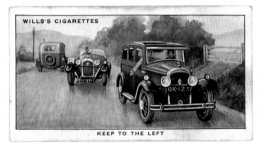

KEEP TO THE LEFT

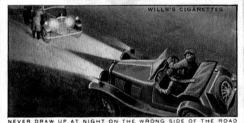

OVERTAKING IN TOWNS

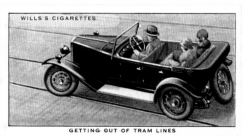

GETTING OUT OF TRAM LINES

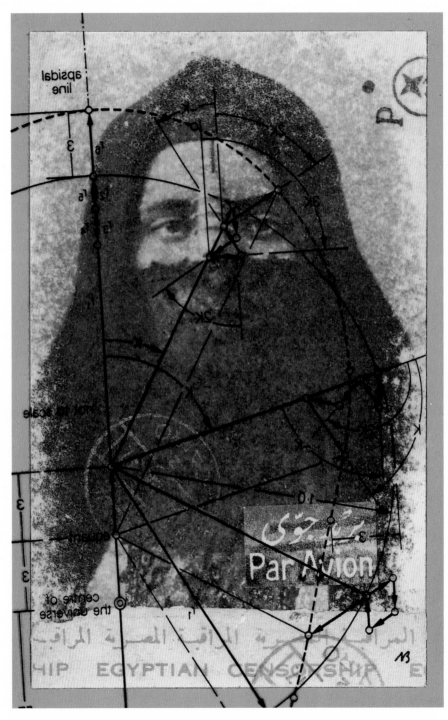

[*Pre-veiling Geometry*] The simple beauty of traditional North African clothing and the Arab fascination for geometry feel totally right together.

< 68 >

Postcards

In 1869, the Austrians issued the first postcards, and a year later the British followed suit. However, the earliest picture postcards didn't emerge till the Germans quietly started what was to become a universal trend. Without realizing it, they were setting free a torrent of images on the unsuspecting universe.

Humor, landscape, people, animals: at some point or another everything under the sun found its way onto a postcard. The cards we choose point us toward our tastes and preoccupations. I collect cards portraying North African women from the early 1900s. Why? Because I'm fascinated by their almost catlike sensuality.

Those who know the Griffin and Sabine books will realize that I not only collect postcards but also make them

from scratch, like the card titled *Pre-veiling Geometry* on the facing page.

In analytical terms the postcard could almost have been designed as a model for the relationship between the conscious and the unconscious. The text deals with the day-to-day practicalities and the image represents the dreamer's world. When you look at old cards, it's curious how often the front and back express conflicting or ambiguous messages. A bold, risqué photo or illustration can be glossed over with a simple greeting: "Mildred. Sunshine wonderful. Paddling everyday. Yours, George."

In the past, postcards were often sent without any written message, just an address and a stamp. Was it that the picture was left to function as a miniature gauge of the sender's state of mind?

[*Blue Flapper*]

< 69 >

47 GRANVILLE. — La Pêche du Lançon. —

[*Hernia*] This guy will allmost certainly need an operation at some future date.

< 73 >

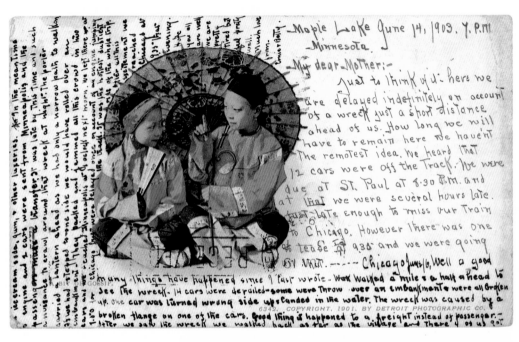

[*Back to Front*] Not everyone shies away from writing. Some folks use every available inch of space to fill in the news.

< 74 >

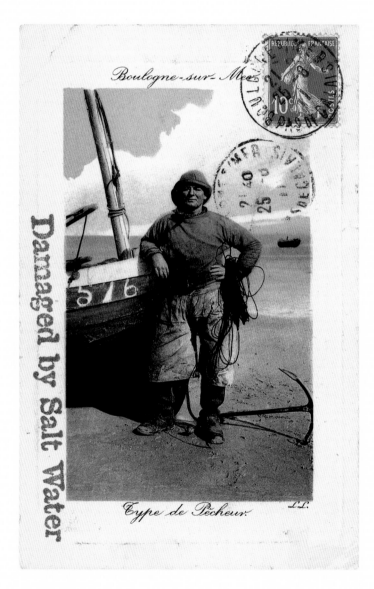

Boulogne-sur-Mer

Damaged by Salt Water

Type de Pêcheur

[*Damaged by Salt Water*] The perfect pose and a sou'wester to be proud of.

< 75 >

[*Blocks and Cuts*] Rubber stamps
are far from the only block
printing tools. Wood, an eraser,
and even a potato can easily be
used. This impression on hand-
made paper is taken from a
linocut.

Rubber Stamps

When I was about nine I had a John Bull printing set consisting of minute back-to-front rubber letters that had to be slotted into a wooden groove with a pair of tiny tweezers. I think I printed my name twice!

Twenty years later I received a rubber stamp of a hippo for my birthday. I refrained from uttering, "That's nice, but what the hell do I do with it?" I'd probably have thrown it in a drawer and forgotten about it if the foresighted gift-giver hadn't also included a black ink pad in the package. I stamped the hippo on a scrap of paper, then I gave it a twin, then I stamped the gas bill, then I stamped all the spare bits of paper on my table, then I stamped the back of my hand. After that I carefully put the hippo and the ink pad in a box . . . and forgot about them!

More years passed and I found them again. The ink pad had long since dried up, but I wanted to see if the hippo would work in a collage, so I bought a fresh pad and tried it out. It seemed awkward, but I could see the potential. I persisted. I tried applying it in different ways with different amounts of inking. Slowly I got the hang of how to integrate the image into the bigger picture.

My next leap came when I discovered a store that sold nothing but rubber stamps. I hate "cute," so I passed over the shelves with teddy bears and floral frippery and homed in on the odd stuff—the insects, the archaic machines, and the prewar postal cancellations of Fiji. For a while, other people's designs were ample to play with, but it was only a matter of time before I started doing my own rubber stamps. I was lucky to link up with a company that, as well as publishing my designs, is kind enough to create the one-offs I need for my books.

Of all the methods of reproduction at an artist's disposal, rubber stamps are probably the most overlooked as a serious art tool. Maybe the immediacy makes stamping seem too easy. But the truth is that a rubber stamp is like a pencil. It's not a matter of just making a mark. It's how you use it, what ground you place it on, and how you position the content in context with its surroundings.

[*Afghan Cat*]

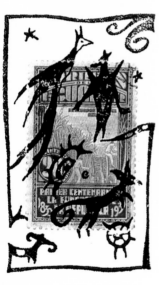

< 78 >

Registered
LOST

WARNING:
INADEQUATE GRAMMAR

Personal:
ABUNDANT WITH SALACIOUSNESS

Armagedon:
last day cover

PRECIOUS GIFT
pre-broken!

Officially late

FRAGILE
TEMPERAMENT

O.H.M.S.
POSTAGE DUE

TO BE READ
between
THE LINES

**Found curdled
@ Post Office**

VERY PERSONAL
resealed

RETURNED: *inept love letter*

FACING PAGE: [*Sock-on-the-Nose*] Getting a good combination of postage stamps and rubber stamping can be hit or miss. A little to the left or right can make all the difference.

[*Wordstamps*] The post office has a tradition of stamping phrases like "returned to sender" and "damaged by crash" onto envelopes, so I decided I needed my own wordstamps.

< 79 >

[*Picturestamps*] The images I make for rubber stamps vary greatly. The quickest and often the most unusual come from joining two very different line engravings.

FACING PAGE: [*Philatelic Cancels*] In order to convincingly cancel an envelope, it's necessary to build a collection of rubber stamp cancellations.

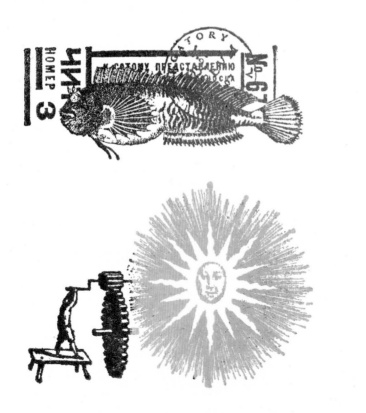

< 80 >

PURGATORY MVSEVM TOPIA 23.07 آفرز

No. 83.
Fernsprechschein.

25 Pf.
für die einmalige Benutzung
des Fernsprechers.

circumterip

PORTO SCRISOREI
40 ПAP
40 ПAP

30

POSTAGE
ONE PIASTRE
PAID
E·E·F
1

Par Avion
بريد جوى

ONE PENNY

4 ØRE

POSTE LOCALE
Service Mixte
Taxe Ext.
Taxe Int. 10
TOTAL

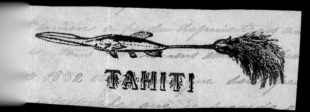

TAHITI

.8.

ARBAH
4 3

G POSTAGE H
H TWO PENCE G

AIR MAIL
SAVES
TIME AND MONEY

5 КОП.

F.lli SANTINI

FERRARA

FABBRICA
Articoli d'Illuminazione, Ca-
salinghi e chincaglierie

MAGAZZINI
Cristallerie, Vetrerie ed ac-
cessori per Illuminazione

REGISTERED

R

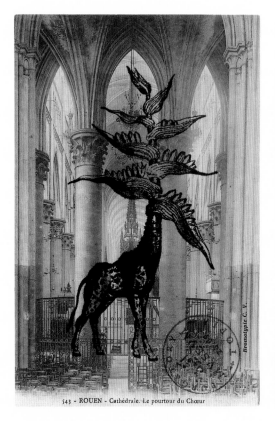

543 - ROUEN - Cathédrale. Le pourtour du Chœur

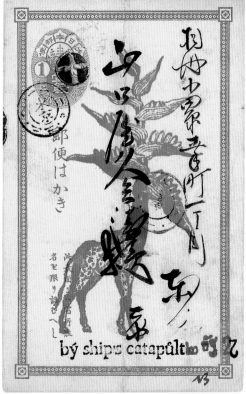

FACING PAGE: [*Fragments*] It's well worth hanging on to ephemera scraps. You never know when they might make grounds for stamping.

[*Divergent Twins*] The colors you use and the ground you choose make a huge difference to the appearance of a rubber stamping. The two giraffes come from the same block but have a vastly different feel.

< 83 >

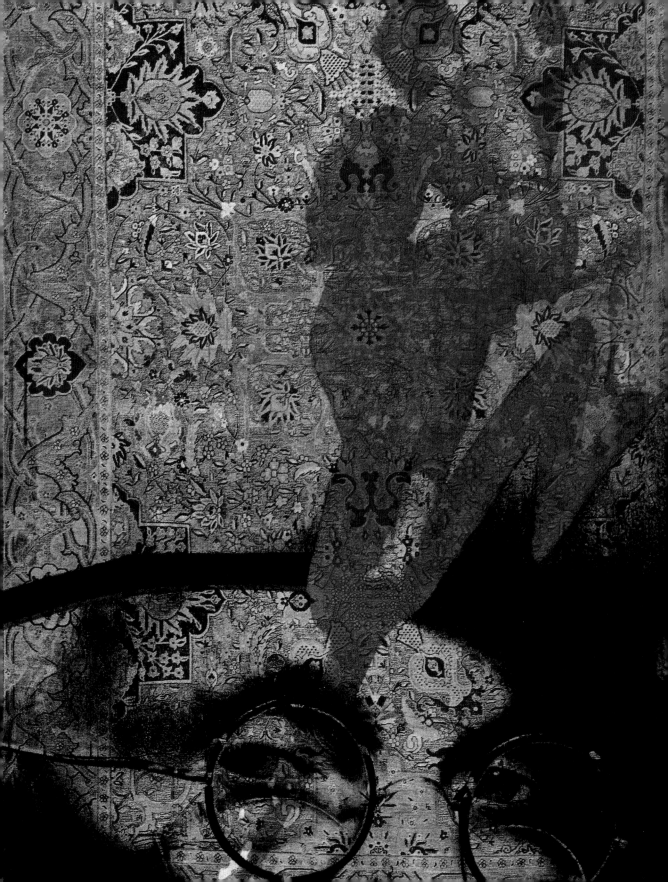

Photocopies

If you are nervous about working directly on a hard-found piece of ephemera, you are almost certainly going to be inhibited in your creativity. A solution to this anxiety is to photocopy the original. Black-and-white and, now, color copiers have become basic practical studio tools. You can copy a piece as many times as you wish onto thin or thick, glossy or matte paper, and then experiment with it as much as you want.

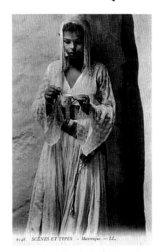

6148. SCÈNES ET TYPES — Mauresque. — LL.

That said, I must admit that I like to use the original artifact whenever I can. The risk of pushing too hard and losing the document or map under layers of collage gives me the same stimulative edge that I get from reading onstage.

The real fun, though, comes from copying a second image directly onto the original ephemera. That means putting the piece though the copy machine (you can run almost any paper through a copier, provided it's not going to disintegrate or jam). You may have to try a number of options in order to get the feel you are after. I tested a bunch of images over pages of antique German type before I came to the blue cow picture (page 88). Why did that one work better than other, more dynamic photos? It's not something I could have predicted—the passive pastoral scene just made its own sense.

On page 86 you'll find a photocopy (not a photograph) of an iris taped to a blueprint of a house. I pressed the flower for twenty-four hours; then, while it still had all its color, I attached it to the plan with masking tape, put it in a clear plastic sleeve, and color-copied it. It came out looking far better than I expected.

You can also copy an image onto clear film. One of the advantages of using transparent acetate is that you can lay your image over any number of backgrounds before choosing a good match. In the example on the facing page I copied one of my paintings and then looked at it transposed over a number of different carpets until I found the one that worked best.

ABOVE: [*Photo-genic*]

FACING PAGE: [*Carpet Alchemist*] Photocopy on transparency.

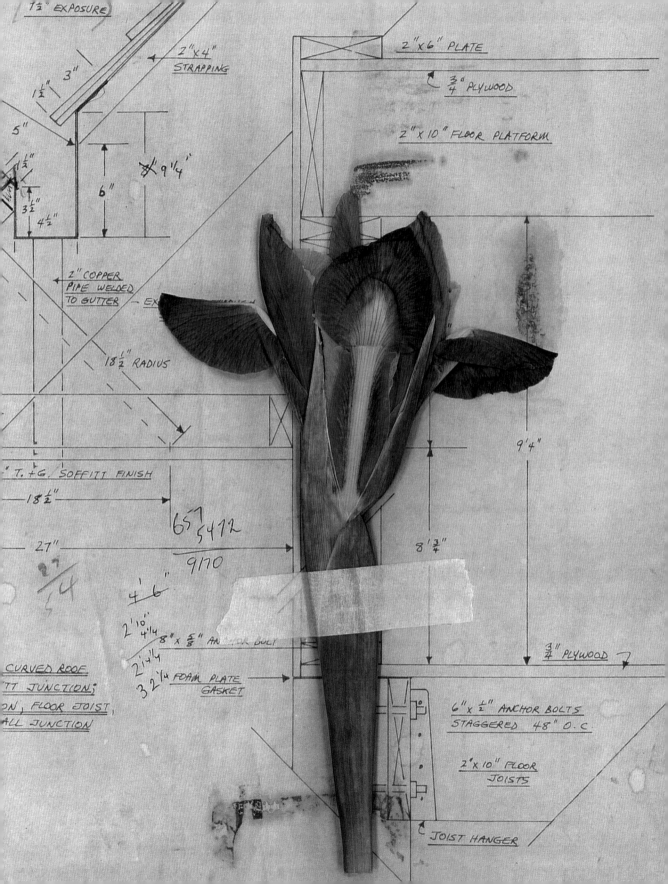

1½" EXPOSURE

2"x4" STRAPPING

3"

1½"

5"

½"

3½"

4½"

6"

8' 9"¼

2"x6" PLATE

¾" PLYWOOD

2"x10" FLOOR PLATFORM

2" COPPER
PIPE WELDED
TO GUTTER

18½" RADIUS

9'4"

8'¾"

" T. +G. SOFFITT FINISH

18½"

27"

65 7
5472
9170

4' 6"

2' 10"
4' 4"
8" x ⅝" ANCHOR BOLT

2' 4"¼

3 2"¼ FOAM PLATE
GASKET

CURVED ROOF
T JUNCTION;
ON, FLOOR JOIST,
LL JUNCTION

¾" PLYWOOD

6" x ½" ANCHOR BOLTS
STAGGERED 48" O.C.

2"x10" FLOOR
JOISTS

JOIST HANGER

FACING PAGE: [*Flat Iris*] When it comes to photocopying flowers, the trick is to press and copy them before the color drains away.

[*Scale*] The size of an image and the space it sits in should always be considered. A small image in a wide field can often create a sense of delicacy.

< 87 >

Die Erforschung des Meeres 359

Meines Wissens sind keine vergleichenden Untersuchungen über den Fettgehalt der Gewebe der Fische gemacht, aber es will mir scheinen, daß er bei den Hochseeformen im Verhältnis zur Schwere bedeutender ist als bei den Bodenformen. Bei dem Riesenhai, den Thunfischen und ihren Verwandten ist er sehr beträchtlich, am beträchtlichsten vielleicht bei den Hornhechten, wo bisweilen die ganze Leibeshöhle neben den Eingeweiden mit Fett gefüllt ist. Die normalerweise fettreichsten Tiere und insonderheit Wirbeltiere, sind die Wale und namentlich die Bartenwale, bei denen zwar alle Organe von Fett oder Tran durchzogen sind, die inneren aber unverhältnismäßig viel weniger als die Lederhaut und das Unterhautzellgewebe. In erster Linie mag es bei diesen Tieren, denen die Behaarung bis auf ganz geringe physiologisch bedeutungslose Reste fehlt, allerdings dem Wärmeschutz dienen, aber daneben wird es ganz gewiß in hervorragender Weise als ein Mittel, welches das spezifische Gewicht ganz bedeutend herabzusetzen imstande ist, anzusehen sein. Am wirksamsten werden da, und namentlich bei den Bartenwalen, die merkwürdigen Verhältnisse des Skelets sein, dessen Knochen, auch die langen, markröhrenlosen der Gliedmaßen, im höchsten Grade schwammig und durch und durch mit Tran durchtränkt sind. Auch die ausgestorbenen großen Reptilien (Ichthyo- und Plesiosauren), von deren Leichen vielleicht das meiste Petroleum herrührt, waren außerordentlich tranreiche, vermutlich warmblütige, pelagisch lebende Tiere; auch verschiedene, im höchsten Maße an das Leben im Meere angepaßte Vögel sind sehr reich an Fett. Die Pinguine oder Fettgänse führen ihren Namen nicht umsonst.

Eine wichtige Eigenschaft vieler Oberflächentiere des Meeres ist die Durchsichtigkeit der Gallertgewebe vieler und sehr verschiedener Formen und der Schutz, den sie dadurch haben, denn die betreffenden Tiere werden durch diese Eigenschaft tatsächlich unsichtbar, und oft verrät nur die Färbung einzelner Teile, des Eingeweidetrakts, äußerer Anhänge, der Augen u. s. w., sowie die Bewegungen ihr Vorhandensein. Man kann sich denken, daß ... nach diesen Geschöpfen suchenden Naturforscher schwer wird, sie zu finden, ein umherschwimmender, räuberischer Kalmar oder Fisch, oder ein vorüberfliegender Vogel ... Hunger zur Eile anstachelt und die daher zum langen Suchen kaum Zeit haben, ... leicht übersehen werden. Die Mehrzahl der pelagisch lebenden verschiedenen Quallenformen ... durchscheinend bis durchsichtig, am meisten wohl die ... Rippenqual... von ... die trotzdem ... namentlich durch das prachtvolle ... der Reihen ... bewegten Ruderplättchen ... Umständen sehr bemerkbar werden, ... im Sonnenschein und ... pelagische Ringelwürmer, ... aus den Familien der ... Amphinoiden, Glyceriden, Phyllo... u. s. w. sind durchsichtig wie Glas und ... sich höchstens durch ihre schwarzen oder roten Augen, oder durch ... in jedem Auge paarig auftretende, farbige drüsenartige ... Auch die ... sich ... deutlich markierenden Verdauungsorgane und die Augen fast völlig durchsichtige Krebse, namentlich aus der Gruppe der Garneelen, bewohnen die Oberfläche des Meeres, ebenso nicht wenige Weichtiere und sogar Kopffüßer. Die Ruder- und Kielfüßer sind bei ihrer pelagischen Lebensweise gleichfalls meist durchscheinend bis durchsichtig. Durch den Leib der 3 Zentimeter langen, schalenlosen Phyllirhoë bucephala des Mittelmeers kann man hindurchlesen.

Die an der Oberfläche der Hochsee lebenden glasigen Fische sind nur Larven und seltsamerweise gerade von auf dem Boden und zum Teil an der Küste sich aufhaltenden Formen. Leider sind diese Verhältnisse durchaus noch nicht genügend klargestellt. Man hat diese unfertigen Tiere,

[*German-Speaking Cow*] Unless an old book is of the highest quality, you are never really sure what was thrown in the original pulp. That means that any given page will respond differently. The paper in this German book is prone to magnify patches of magenta ink—one reason for choosing a magenta-free cow.

< 88 >

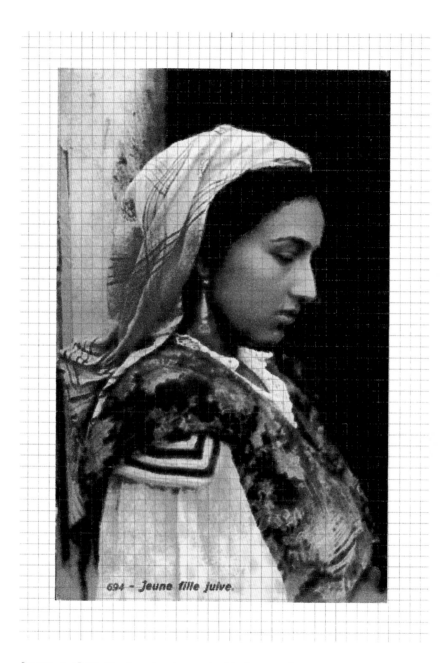

694 - Jeune fille juive.

[*Grid Locked*] Unlike the other images in this chapter, the young woman portrayed was fed through a computer printer. I used a page from an old stamp album and watched as the water-based ink fixed on the white surface but was rejected by the blue, oil-based grid lines.

< 89 >

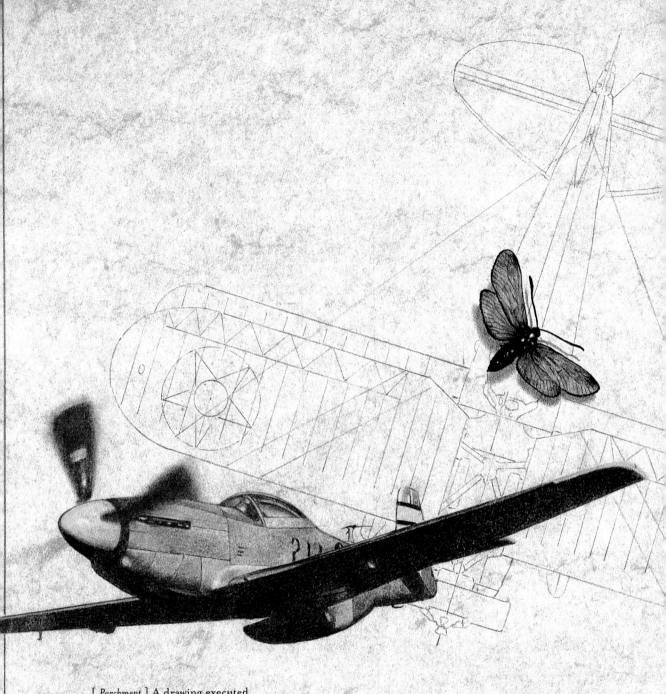

[*Parchment*] A drawing executed
on parchment paper can be
gentle on the eyes. This draw-
ing of a plane and butterfly
uses a combination of colored
pencil and graphite.

Drawings

Anyone who has tried to assemble a piece of furniture from an instruction sheet composed by a dyslexic, Scandinavian sadist knows what panic is. I've noticed that as soon as the word drawing gets mentioned, many people take on a similar look of petrified hopelessness. Unlike the example of the unjoinable joinery, drawing has become such a daunting challenge for obvious reasons. Quite simply, the art of seeing is seldom taught in schools. Drawing has pretty much been deemed a redundant activity unless a person is "artistic" and headed for art college.

I cannot overcome anyone's fear of drawing. A fear that was probably fixed in the first instant by a combination of exercises in telegraph-pole perspective and enforced periods of sitting in front of a bowl of fruit waiting for it to transmogrify itself onto paper. Instead, I'm going to try to stimulate those who want to play a little.

If you want to draw something that you have a good reference for, don't be shy about using a light table or even a windowpane. To add extra interest to a drawing, place a piece of ephemera directly over your reference picture, put light behind it, and trace the image onto the ephemera's surface. Don't get hung up on always having to draw from scratch. Certainly it's a skill I encourage in the long term, but at the start, functionality is the key. Even Canaletto used a camera obscura to project the canals of Venice directly onto his studio desktop.

There are so many different ways to draw. Some require a facility for rendering, but others almost work better without it. The petroglyph drawings on page 95 are done with a tiny dipping pen dragged shakily over a rough, uncontrollable surface, whereas the charcoal face on newspaper (page 94) was more like a therapeutic outburst.

[*Pointillizing a Mummified Cat*]

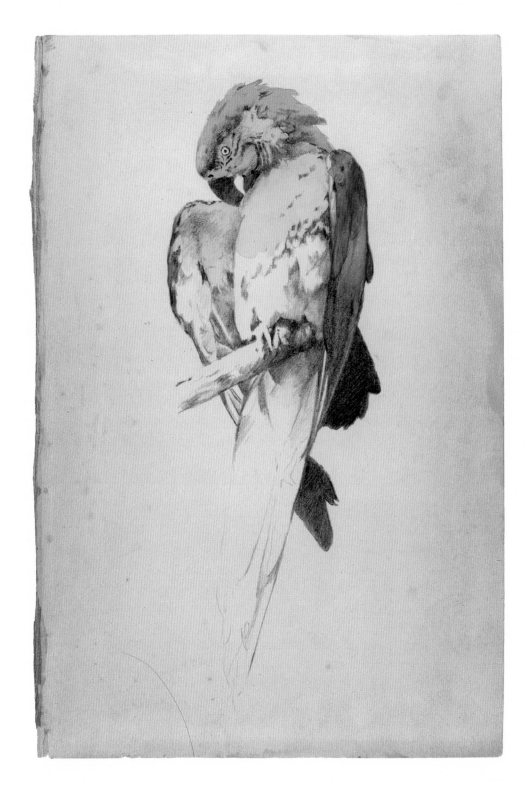

< 92 >

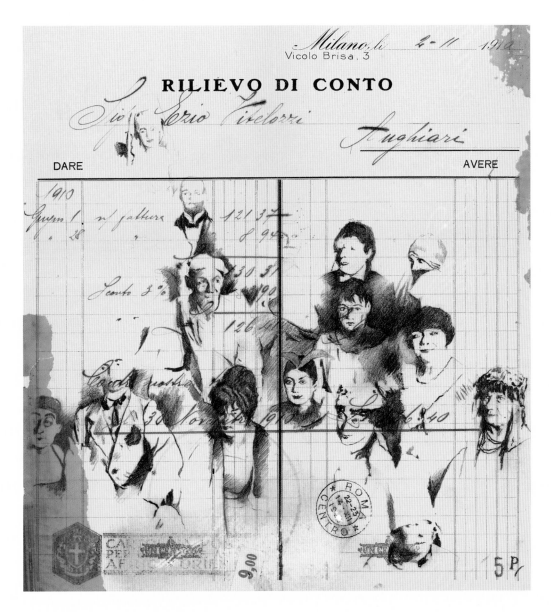

FACING PAGE: [*Parrot on the Fly*] To make a drawing look old, coat the paper with strong tea. If you wanted to speed up the aging process, subject the paper alternately to cold and dark, and then heat and light. But the simplest way to make a drawing appear old is to do it on an old book flyleaf.

[*Fancy Dress*] In the introduction I described this Italian invoice as a concept. Does its reality (albeit an invention) enlighten or confuse historical reliability?

< 93 >

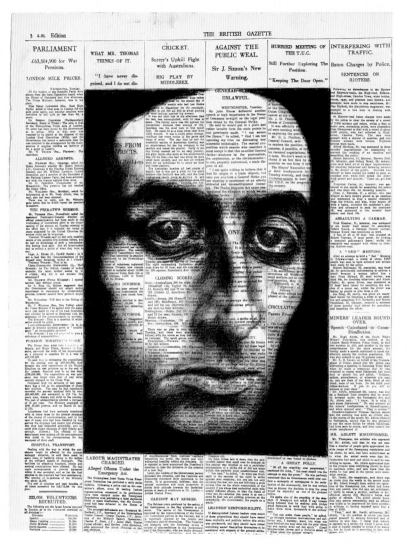

[*Graphic Journalism*] Drawing with charcoal and compressed charcoal directly onto yellowed newspaper can give an image an extra dimension of texture and implied context.

FACING PAGE: [*Petroglyphs*] Not all drawing needs be done dry with pencil or charcoal. For example, a black ink brush drawing can be effective when laid over colored tissue saturated in matte medium.

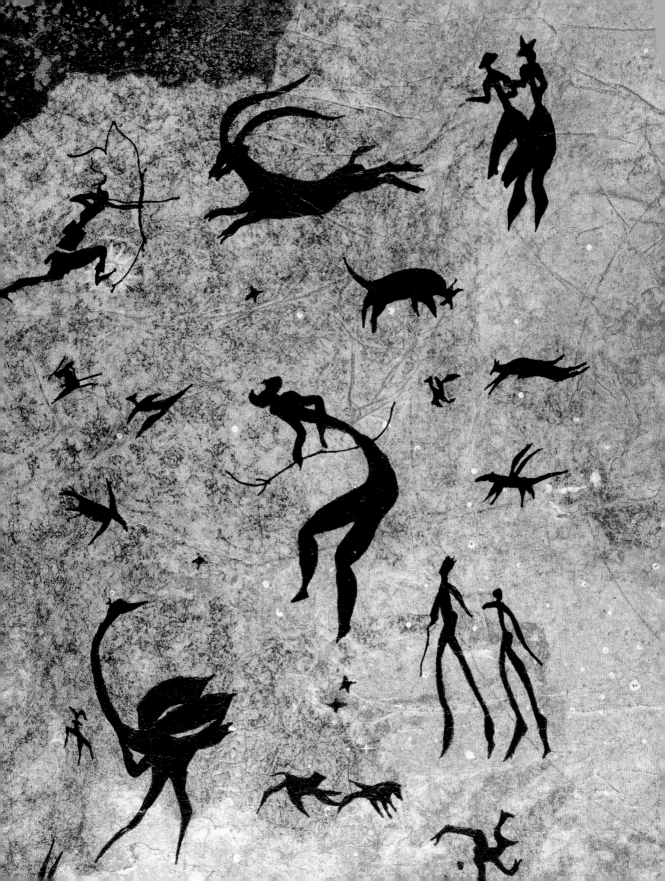

[*Picturegram*] This storekeeper's
account list looks as if it
has been eroded by a
sea of mice.

Handwriting and Type

At one time, handwriting was commonplace and the literate were adept at reading it. Eyes were attuned to comprehend individualistic styles and letter formations; the handwritten word was a reflection of an individual's personality. You could establish whether your correspondent was tight and careful or open and gregarious by the letters shaped by his or her pen.

Now, for reasons of expedience, we teach a uniformly constructed alphabet and non-self-expressive handwriting.

When the mechanical writing revolution came first with the typewriter and then the computer, fewer and fewer people felt a need to handwrite. And those who did were faced with readers who had little patience and expected instant legibility. It is hardly surprising then that today we look with abstract awe at what seems to be the swirling complexities of an everyday hand from one hundred fifty years ago. It could be said that calligraphy keeps the practice of handwriting alive, but it seems to me that calligraphy is a more conscious act—a precise and formal kind of script that is usually perceived as a decorative craft. As much as I admire calligraphy, I'd rather see natural handwriting that takes pleasure in its eccentricity and informal beauty.

Typography has been around for more than half a millennium. From wooden block to metal press to Lettraset and golf-ball typewriters, the march of the preformed alphabet has been inexorable. In its own way, type is extremely pleasing to the eye. There are more typefaces than visible stars in the night sky, and they offer the artist a vast array of shapes and forms to tinker with. For me the most fascinating aspect of type apart from the pure letter shaping is the relationship of one letter to another. Whether floating around on a page or lined up for legibility, every letter in every alphabet has a relative, comfortable distance from the previous one. A *t* next to an *o* requires a different spacing than a *t* next to a *w*. There is no formula that can be applied to all letters and all faces.

[*Changing Typefaces*]

РЕПИША

рого НОМЕР ВТОРОЙ.

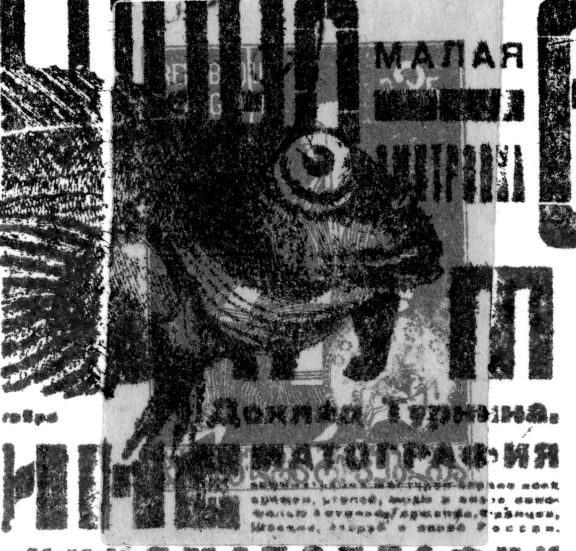

МАЛАЯ

доклад Терина.

КИНЕМАТОГРАФИЯ

КИНЕМАТОГРАФИИ

ПРЕДСТАВИТЕЛИ СОВРЕМЕННЫХ ГРУППИРОВОК

ВЫСТУПЯТ:

Are our souls stranded, unable to express themselves in a suitable language? We don't dream in words: our imaginations are picture-based. Images are multi-faceted, & when combined with others of their like, offer multiple possibilities that become so dense they are only negotiable by means of intuition. They are inconstant... fiable therefore they appear to be unreliable. That's why our overt commitment to linear logic moves us away from an understanding of images. We live by the word which... we can define... But we are... tent, we settled. adults never prop... heard this... feel only... & seen.

is hardly surprising, as we have become separated from the pictures that are the wellsprings of our being. It would seem that few people today feel truly comfortable with images — our dream

[*The Illustrated Letter*] If you choose to illustrate a letter, you can work around the image . . . or go through it.

FACING PAGE: [*Russian Fish*] When rough-cut text is blown up many times its original size, the edges will take on a pleasing asymmetry.

< 99 >

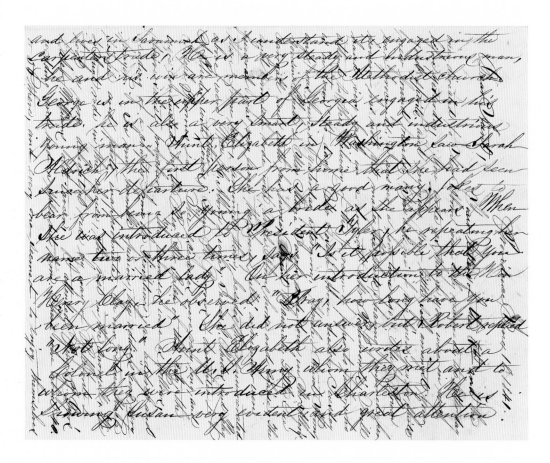

[*Two-Way Handwriting*] It's surprising how legible script traveling both ways at once can actually be.

FACING PAGE: [*Words and Numbers*] I'd never used gold leaf till I attempted this typographical experiment. The ground is made of odd scraps of typographic ephemera, followed by acrylic stain, then the gold, and finally a transparent overlay of a Spanish map and an inverted 2.

< 100 >

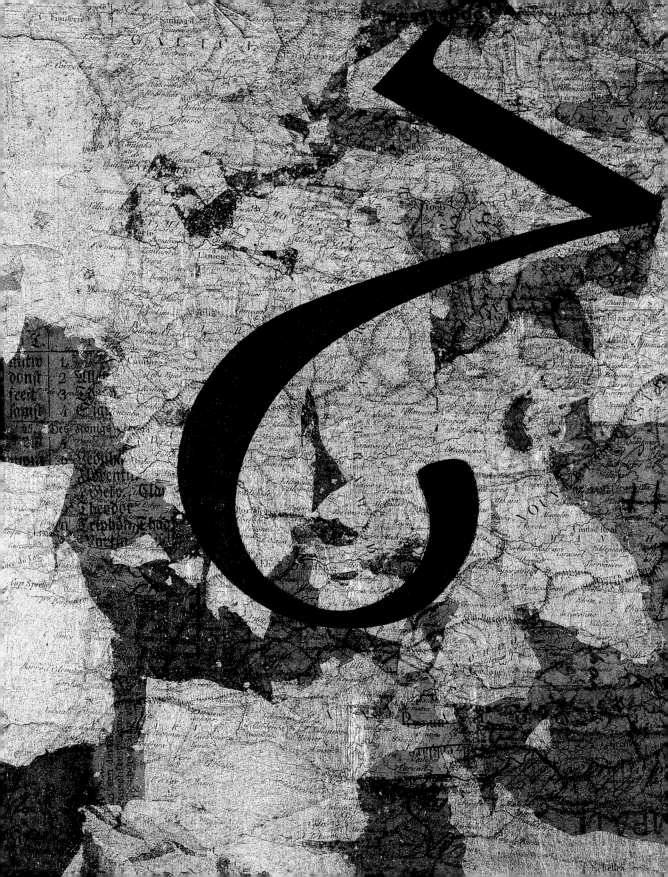

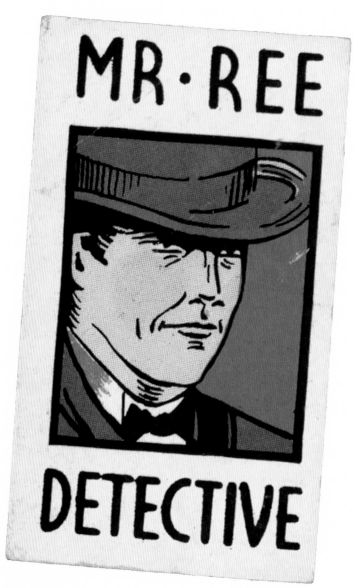

[*Gumshoe*] An enlarged playing
card of a trilby-touting sleuth
from an unknown game
(1940s).

< 102 >

Games

I guess all those hours as a kid playing with jigsaws, dominoes, playing cards, and chessmen are what has led me to include a chapter on games. I even used to invent games: making the rules, cutting out bits of cards, designing the money.

Old games cover an amazingly wide spectrum from the cheaply printed ones on low-grade cardboard to the ornate, delicate, and highly expensive. Some come in boxes with single elements missing and some turn up as single, isolated pieces devoid of packaging and rules. I love these markers whose surfaces have been oiled and rounded by touch. They emanate a foot soldier's sense of purpose.

I hunt for games all over, yet I've bought most of the best ones at garage sales. While they can be purchased from antique stores and off the Web, I find it much more satisfying to stumble onto an early bingo game or a pack of Old Maid amongst someone's cracked teacups and armless Barbies. Once you start rooting around, you'll find all kinds of interesting game material in unexpected corners. In a fishing tackle box at a yard sale, I came across three wooden Scrabble letters and the metal top hat from an old Monopoly set—I'm still trying to work out the angler's intent! If I can infuse that kind of curiosity of connection into my artwork, I'll be perfectly happy.

[*Down-at-Heel Old Rook Box*]

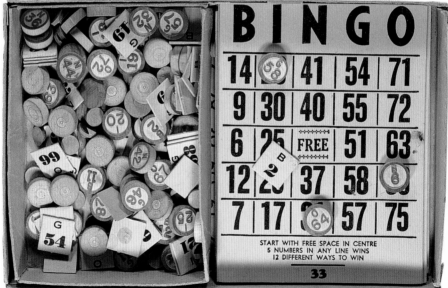

[*Bingo*] Putting together the box cover and the inwards of this old bingo game, I imagined someone was staring at it and being reminded of a wet afternoon from their childhood when they sat on a living room floor waiting for their number to come up.

FACING PAGE: [*Spread Hand*] The broken deck of cards I bought in Camden Passage, London. The stretched green baize came from a cloth shop on Pender Street, Vancouver.

< 104 >

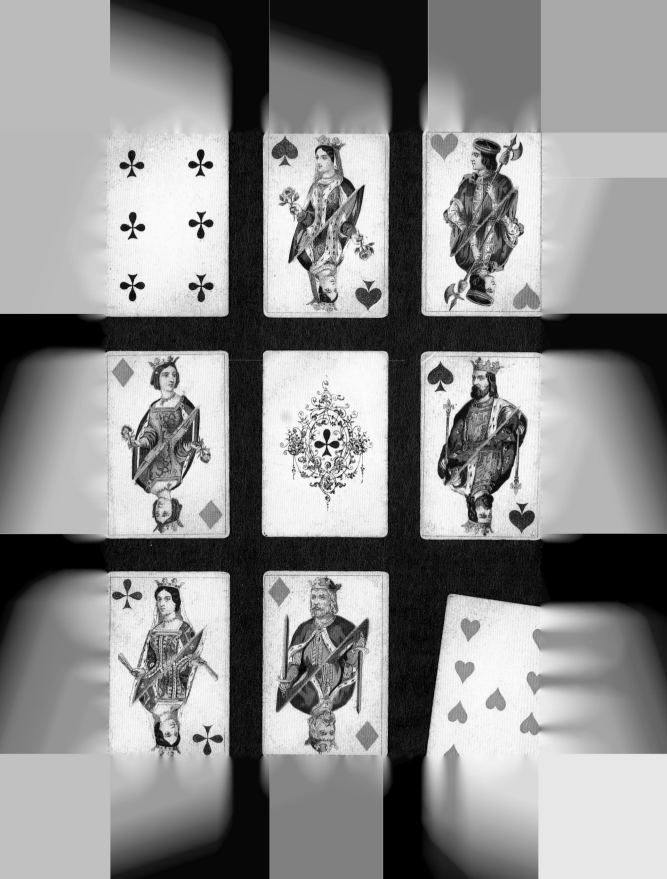

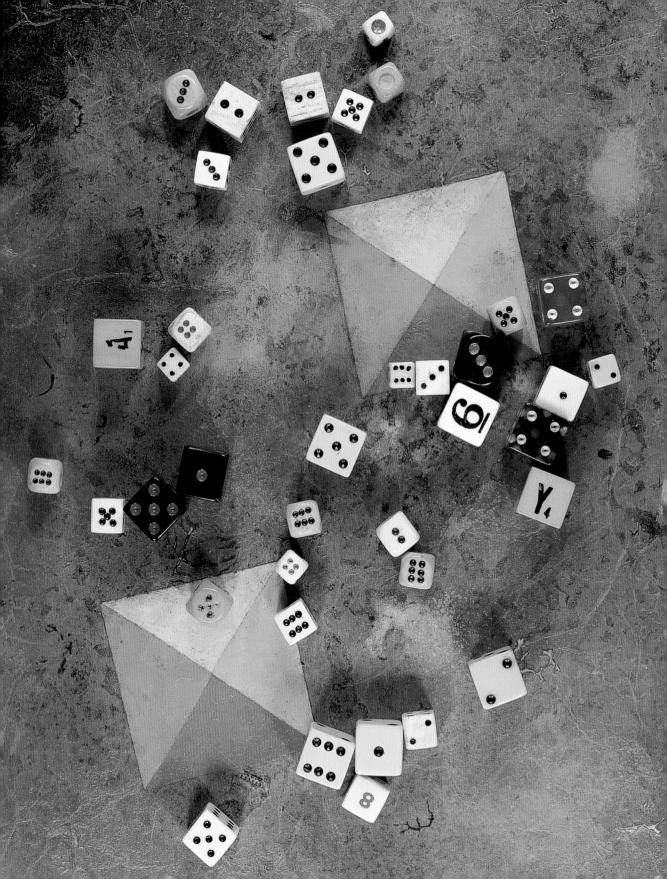

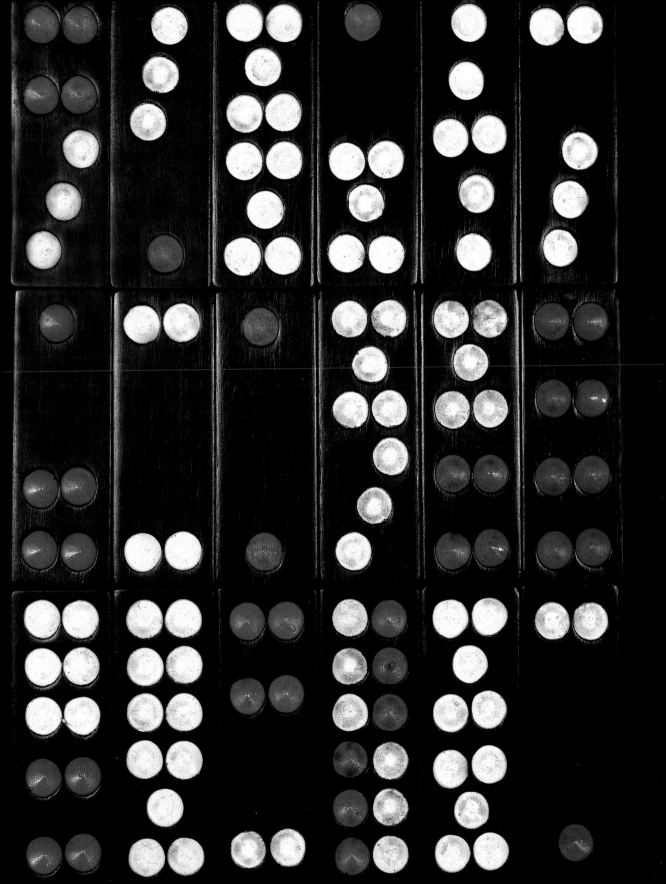

[*Blackpool Tower*] I bought this jigsaw on eBay knowing there was a piece missing. I put it together, took out a few more bits, and then inserted a playing card of a giant stuffed gorilla from the 1933 Chicago World's Fair.

PREVIOUS SPREAD, LEFT:
[*Die Cast*] I'd been picking up the old dice for a while before I realized I had a collection. This handful of dice was thrown across a painting of the pyramids seen from on high.

PREVIOUS SPREAD, RIGHT:
[*Code*] Even though the placement of these old Chinese dominoes was random, it seems like there must be a mathematical cipher running through the order of spots.

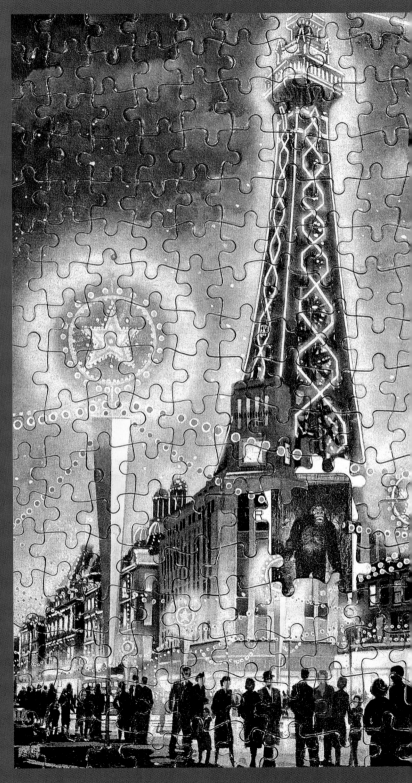

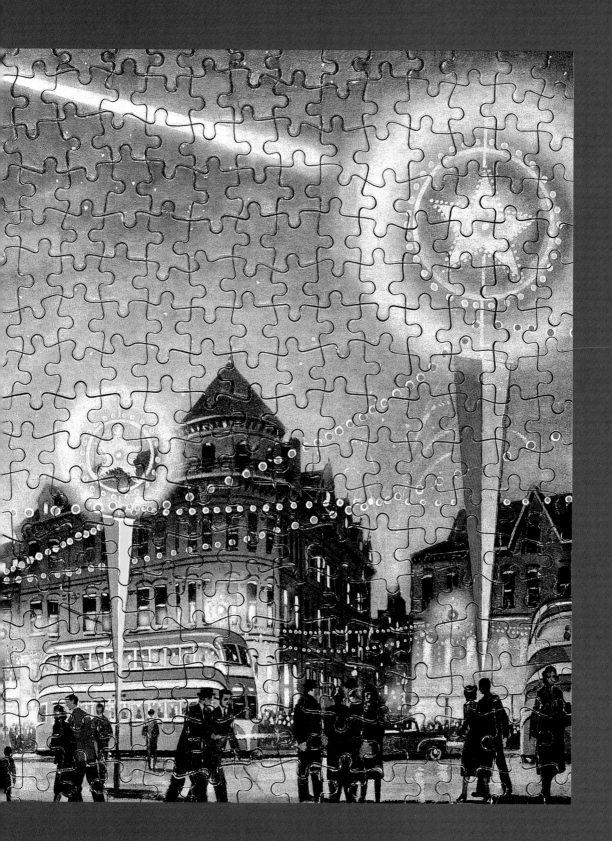

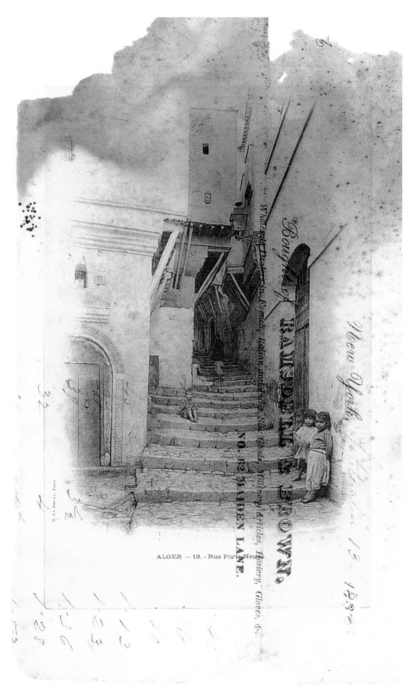

[*Alger 19*] Invoiced postcard.

< 110 >

Collage

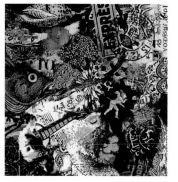

I have left collage until last because it is the sum of all the previous chapters. Every technique and every combination of ideas can be incorporated within collage, and only paint need be added to visually hold the parts together.

The method and practice of collage tend to encourage swiftness, but the speed with which layers can be built can also serve as a trapdoor to a chaotic mess. As fast as you can create a vital collage, it can also collapse under you. One minute everything is looking good, the next the various elements have lost their sense of relationship and become a muddle, like too many colors mixed together into a grungy brown.

I prefer to use fragments rather than whole pieces of found material, which means my pictures tend to be small. Large collages may be quick eye-catchers, but they are often easily glanced over. When a picture has to be approached and observed closely, the viewer is pulled into a world that demands committed inspection.

These smaller collages tend to need more nurturing, and when I finish the preliminary stages of assemblage I go back into the picture with a small brush and carefully rework and retouch any harsh or uncomfortable edges. This merging stops the eye from jarring and allows the viewer to see the work as a continuous piece rather than a series of partially related sections.

Anyone can slap a collage onto paper—only time and practice will allow you the skills and understanding to elevate your expression into one of dialogue and harmony. Developing a technical knowledge can help, but technique alone won't make a worthy collage. Keep in mind the content, but don't be too literal. And always allow yourself the freedom to experiment without losing sight of the need to compose.

[*Fish and Cherub Collage*]

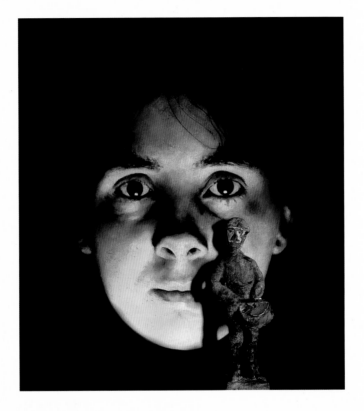

[*The Drummer*] An oil painting of a young woman's face I did in the 1970s. Looking at it again recently, I felt as if it had come from the period around the First World War, so I attached the wooden soldier to help fix the collage in time.

FACING PAGE: [*Garden of the Fallen Angels*] I was drawn by the *Shadowland* cover, and it reminded me of the remains of the bird that one of my daughters found.

< 112 >

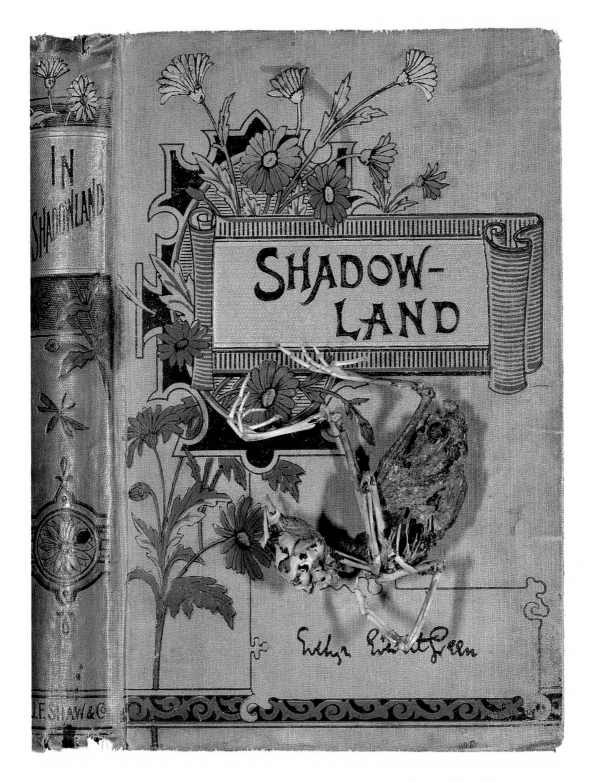

< 113 >

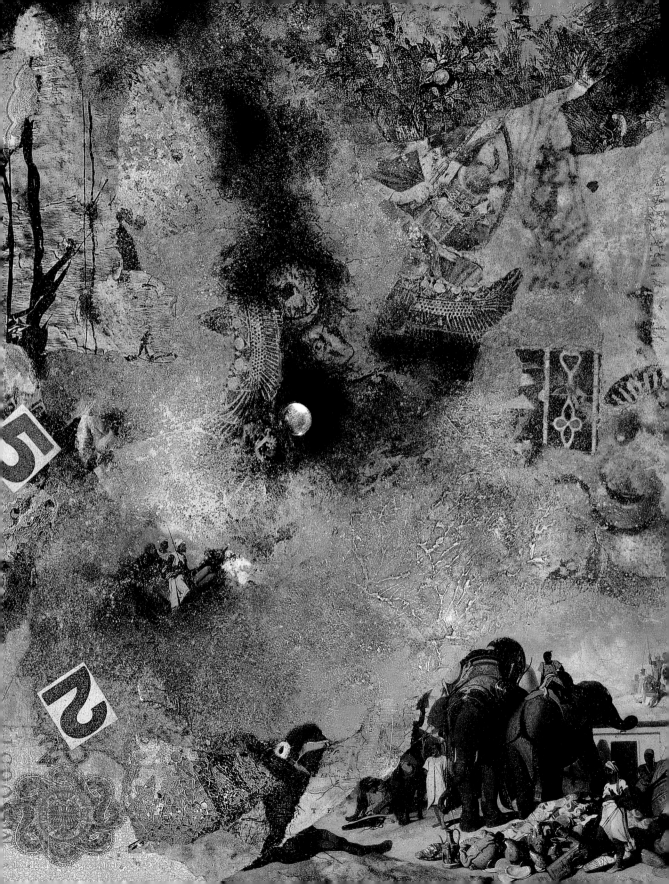

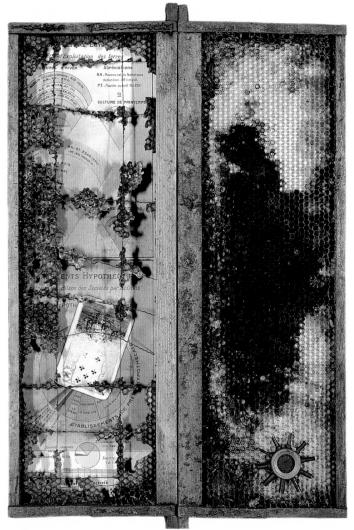

LEFT: [*Double Honeycomb*] Once in a while (not nearly often enough), a work will emerge out of nowhere. I found the honeycomb frames at a garage sale, joined them together, and added two painted book pages, a playing card, and a watchmaker's sprocket. It all came together in a matter of minutes.

FACING PAGE: [*The Kingdom*] This collage is a "show-off" piece. Explaining how I put it together would take years. Applying the paint and found material cannot be done to formula—you have to employ your eye, your heart, your gut, and your slow-learned craft. Materials used here include printed scraps (fifty plus), acrylic paint, watercolor, ink, gold powder, colored pencil, glue, matte medium, and tissue paper.

< 115 >

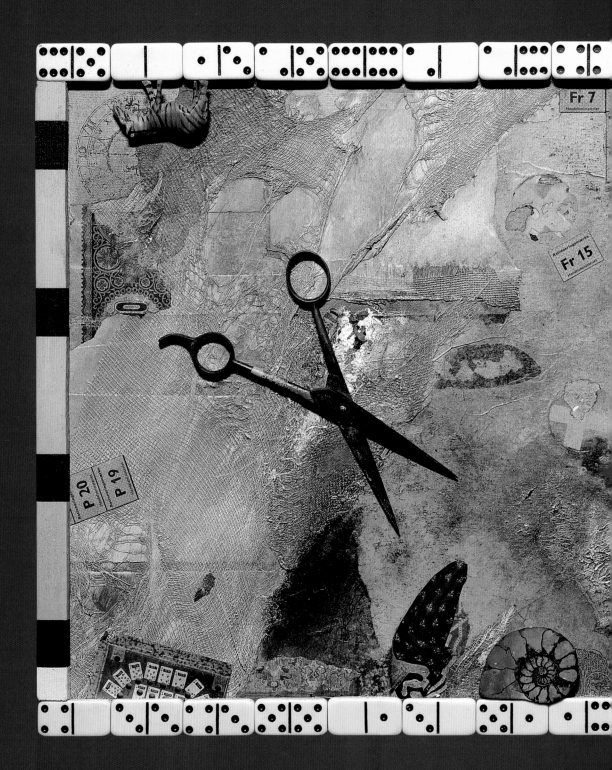

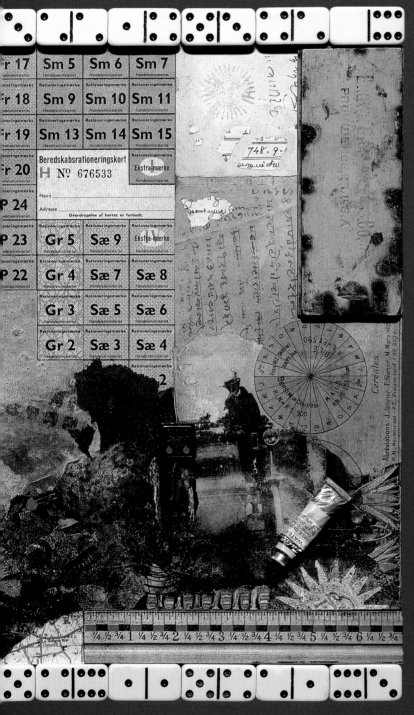

[*Zebra Trail*] Unlike *Double Honeycomb*, this collage had to be fought for every inch of the way. It took weeks of sheer slog to find the right style and tone. Locating the scissors alone took days and days of searching in junk and antique stores.

Player's Cigarettes

Modern Game,
Black-breasted
Reds

разрядъ

ГОСУДАРС

ВНУТРЕННІЙ 4½% ВЫИГ

й на осгованіи постановленія Време